DIRECTOR'S CHOICE
TYROLEAN
STATE MUSEUMS

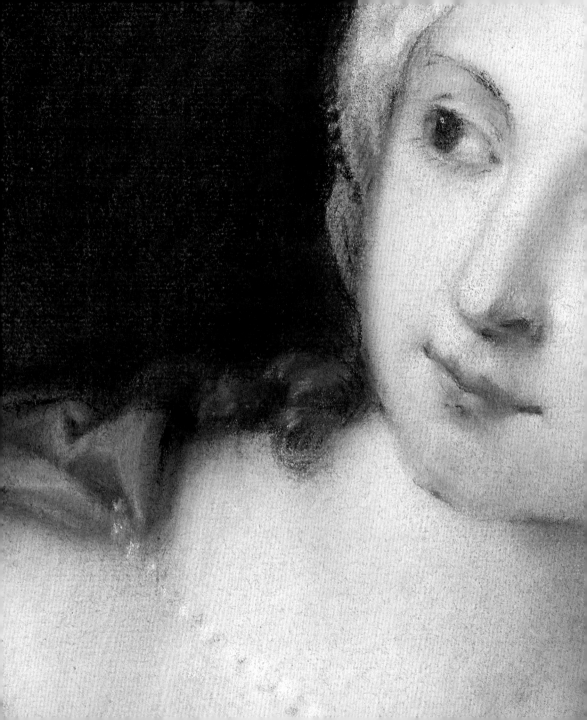

DIRECTOR'S CHOICE

TYROLEAN STATE MUSEUMS

Peter Assmann

SCALA

INTRODUCTION

FOUNDED IN 1823, the Tiroler Landesmuseum Ferdinandeum (Tyrolean State Museum Ferdinandeum) is one of the oldest 'national' museums in Europe. Conceived from the start as a multi-departmental museum, ever since its foundation this institution's view of collecting has focused on cross-disciplinary considerations with special attention to the territory of the Tyrol. As well as the current meaning of the name since the changes to the map of Europe after the First World War, focus on the Tyrol means looking at the historical Tyrol, i.e. the regions of South Tyrol and Trentino that are now part of Italy, together with the Austrian state of Tyrol. The approximately five million items in the collection currently represent two centuries of continuous, resolute scientific museum work in a great variety of fields, as well as intriguing stories of individual collections that often produce unexpected results. For example, who would expect to find a single object as fascinating as the Artuqid bowl or a collection centred on works of the Dutch Golden Age in Innsbruck. Like so many others, this Dutch collection, which includes a painting by Rembrandt, came to the museum from the private collection of a Tyrolean art lover. Right up to the present day, wide-ranging support for the museums' collection activities has been guaranteed by an active museum society together with the unwavering assistance of the State of Tyrol. So for many decades the work of collecting carried out in this institution has ranged from the oldest traces of life to current contemporary art. Even though some specialisation in scientific research has gained acceptance – for example, our research into lepidoptera species has made us one of the main international centres for entomology – the interdisciplinary approach is dominant in all areas.

In 2007 the Museums of the State of Tyrol and the Vereinsmuseum Ferdinandeum were brought together in the newly founded institution Tyrolean State Museums, which meant another massive expansion of the now jointly managed collections. Today the Tyrolean State Museums work on five sites: the Tyrolean State Museum Ferdinandeum, the Museum of Tyrolean Regional Heritage, the Hofkirche with the world-famous tomb of the Holy Roman Emperor Maximilian I (with the

FROM TOP:
The Tyrolean State Museum Ferdinandeum, the Museum of Tyrolean Regional Heritage, the Hofkirche and the Tyrol Panorama with the Museum of the Imperial Infantry.

figures known as the Black Men), the Museum at the Armoury (Zeughaus), and the Tyrol Panorama with the Museum of the Imperial Infantry. Lastly, with the internationally admired building of a new Collections and Research Centre that has been the object of much international admiration, we now have a central complex with adjoining workshops, restoration studios and offices.

The museum takes its name of Ferdinandeum from the Austrian Emperor Ferdinand I (1793–1875), who not only officially approved the founding of the museum but also agreed that it should be named after him. His nephew Archduke John had already attempted to organise the foundation of a museum of this kind in the Tyrol in the previous decades, but this was not possible at the time because of the Napoleonic wars. The former Princely County of Tyrol experienced massive political changes after the First World War but, even under changed conditions, the Tiroler Landemuseum continued to focus its attention on the territory of the historical Tyrol. Today the European region Euregio Tirol–Südtirol–Trentino represents the museums' interest framework.

The present selection endeavours to display the diversity of the various areas of the collection. Most importantly, special 'speaking objects' relating to regional history aim to reveal their significance in the international context. However, particularly for a traditional institution like this, with its long and varied history, there is the constant challenge of keeping up to date with new developments in order to demonstrate once again the special significance of the Museum – as a communication-oriented institution continually having to come to terms with different cultural and historical identities and current scientific research.

The Tyrol's largest rock crystal

One rock crystal from a group of seven, approx. 236 kg, 55 x 50 x 120 cm,

Site of find: Dorfer Valley, East Tyrol, 1969

Tyrolean State Museums, Department of Natural History

Inv. no. 7001

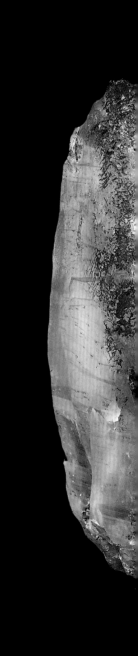

IN OCTOBER 1969 TWO 'STONE HUNTERS' from East Tyrol, Josef Unterguggenberger and Norbert Moser, made a sensational mineral find. In a fissure about 2,700 m above sea level in the Dorfer Valley near Kals in East Tyrol they discovered several exceptionally large rock crystals. The largest was 120 cm long and weighed 236 kg. Neither of the two mineral hunters had reckoned on making such a find. Transporting them down into the valley proved very arduous and complex over the almost impassable terrain; it required a good deal of improvisation and took two days. In 1973 the two men handed over their set of amazing finds, a group of seven rock crystals, to the Tiroler Landesmuseum Ferdinandeum. Today the two largest rock crystals are on display in the Museum at the Armoury (Zeughaus) in Innsbruck. Unlike typical rock crystals, these giant crystals are not transparent but appear dull and milky because of tiny inclusions and fine cracks. The surfaces of many crystals are as smooth and shiny as glass, whereas others with rough surfaces have had their growth restricted by the natural conditions. Smaller quartz crystals growing in and on the two rock crystals highlight their imposing appearance.

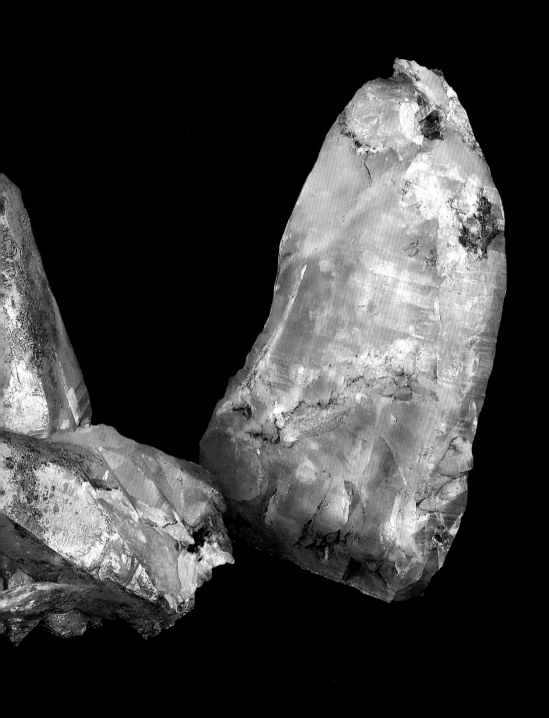

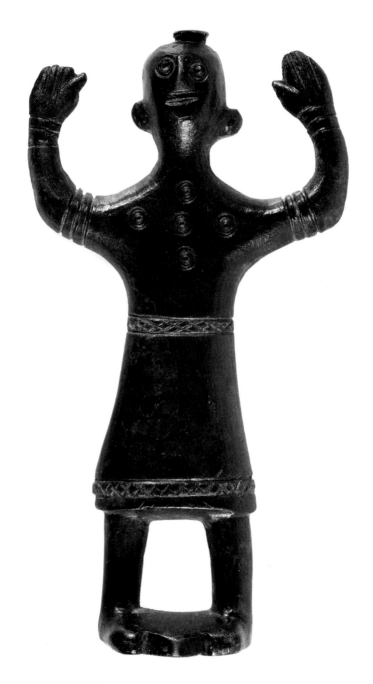

Statuette of a worshipper
Imst–Parzinnalm, La Tène period, 5th–4th century BC

Cast bronze, 8.2 x 4.37 x 0.99 cm

Tyrolean State Museums, Department of Archaeology

Inv. no. U 4156

THIS BRONZE STATUETTE of a worshipper comes from the high mountain region of Imst in the Tiroler Oberinntal. Although the circumstances and the exact site of the 1902 find of the bronze statuette in the barren cliffs of the Parzinnspitze have not been passed down, the topography of the area where the worshipper was discovered means that it can be interpreted as a votive offering. It originates from the La Tène period, the mid-fifth or fourth century before Christ. La Tène culture, which takes its name from an archaeological site in Switzerland, followed the Hallstatt period in the Alpine region. It was spread by the Celts, a name first mentioned in Graeco-Roman sources at this time, and by the Raeti in the Tyrol where the Fritzens-Sanzeno culture flourished.

Weapons and tools were already being made exclusively of iron at this time. Bronze was reserved for special items. This human figure with its simple clothing and little ornamentation is created from a few, very clear shapes. The worshipper wears a knee-length, short-sleeved, belted robe, the hem of which is trimmed with embroidery or braid. The classic position of the arms raised in prayer points towards a deity dwelling on the mountain or in the sky. This statuette was probably a votive offering to a deity of this kind, either as a gesture of gratitude for help already received or to ask for divine help.

Bust of a Maenad

Brixen (Bressanone)–St. Andrä (S. Andrea) (South Tyrol), Roman period, 2nd century AD

Cast bronze and almandine, 12.3 x 8.75 x 4.5 cm

Tyrolean State Museums, Department of Archaeology

Inv. no. U 5119

As WAS THE CASE with many other Alpine regions, the integration into the Roman Empire of what is now the Tyrol took place without any known major acts of war. For the Roman Empire – as in later centuries and still today – the Tyrol was of particular importance as a transit region into Germania as well as of economic importance due to its natural resources. No large cities developed there, because of its special location in the mountain valleys, although a few isolated finds provide evidence of the unusual luxury of Roman life in this region.

This small bronze bust is among the most notable archaeological finds from the Roman period in the Tyrol. With its wealth of detail and elegant facial expression it bears witness to the high quality of Roman artwork in the second century AD. The fully sculpted head of the maenad rises from the well-formed torso, which is clad in a chiton (an undergarment worn by both men and women in the ancient world), mantle and nebris (the skin of a fawn worn as clothing in Antiquity). The head is garlanded with ivy. The shining eyes are formed by the insertion of faceted, wafer-thin discs of almandine (garnet). Maenads were the female followers of the Greek god Dionysus, whose worship took the form of particularly ecstatic processions. The expression on the face of this female bust, which is probably based on Greek models, is similarly ecstatic. The precise function of this artistic gem is unknown, but it may have been applied to a piece of furniture.

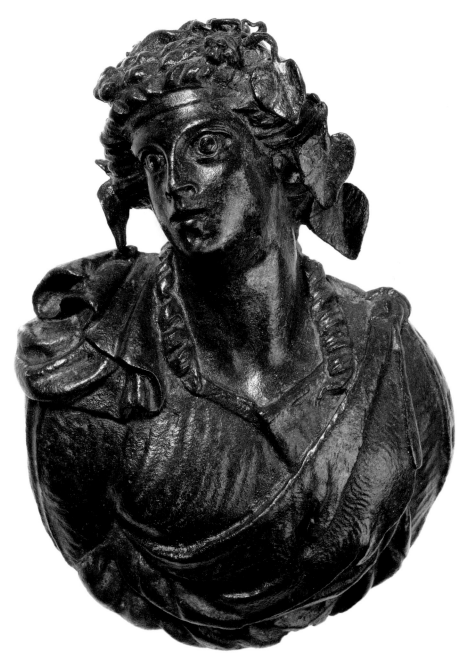

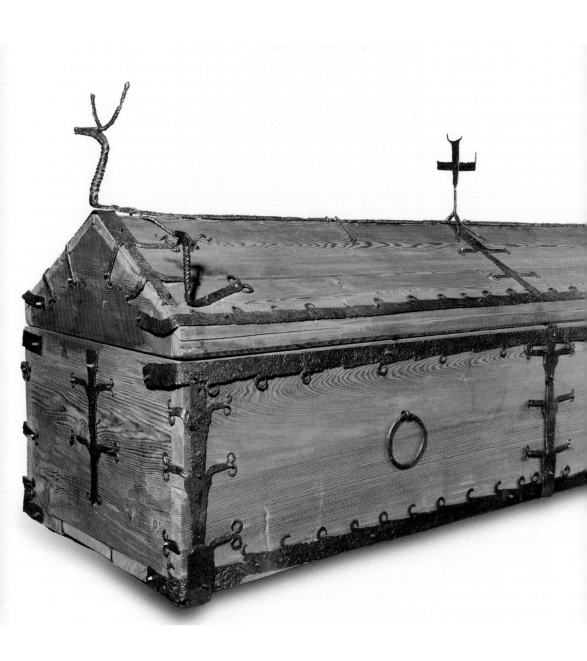

Wooden coffin

Civezzano, grave II, known as the Tomb of a Lombard Prince (Trentino),
Early Middle Ages, 2nd quarter of 7th century AD

Iron, larch wood (modern), 2.36 x 0.80 x 0.785 m (ridge of coffin lid)

Tyrolean State Museums, Department of Archaeology

Inv. no. U 8318

THERE ARE VERY FEW finds relating to the history of Christianity in Late Antiquity in the Alpine region. This makes the discovery of this unique, early medieval wooden coffin, reconstructed from its iron fittings, all the more noteworthy. It originates from the second quarter of the seventh century AD and was found during the excavation of a Lombard cemetery lying a few kilometres north-east of Trento in Switzerland. The unusual quality of the workmanship of the wooden coffin and the accompanying objects led to the assumption that this might have been the grave of a prince. The unique quality of the craftsmanship of this burial find includes a mixture of the decorative styles of the pagan Germanic tradition and the religious world of Christianity, as was customary for the elite of society in the Lombard kingdom. The iron fittings of the wooden coffin show striking animal figures: for example an easily recognisable horned snake, the symbolic protector of the dead. At the corners there are rams' heads, whose function was probably to ward off evil

spirits. However, in a central position on top of the coffin is a Christian cross. A cross, even if made from thin gold sheet, is also part of the valuable grave goods of this Christian man, who was buried lying on his back in an east–west direction.

Artuqid bowl
Byzantium/Middle East, 1st half of 12th century

Cloisonné enamel on copper, diameter: 26.5 cm

Tyrolean State Museums, Department of Art before 1900

Inv. no. K 1036

THE OBJECT KNOWN AS the Artuqid bowl is probably the most mysterious item in the collection of the Ferdinandeum. It is the only known enamel object from the Middle Ages to have an inscription in both Persian and Arabic. According to the Arabic inscription, its owner was the ruler Rükn ed Devle Davud (1114–1144). However, this attribution throws up a few questions, as the particular techniques and the use of copper for the base material suggest a closer similarity to the artistic handicraft of Byzantine objects of the time. On the other hand, the lines written in Persian point to an artist with close connections to this language and to the culture of the Persian court. The images displayed refer to episodes from the legends of the Alexander Romance.

Expensive vessels of this kind, very few of which have been preserved anywhere in the world, were often given as dowries in marriage contracts between Islamic ruling families in the Middle East. As this bowl was probably made by a Greek craftsman specialising in such work and commissioned by an Islamic ruler who felt he belonged to the worlds of both Arabic and Persian culture, it represents unique evidence of the high-quality cross-fertilisation of different cultural traditions in the Middle East in the High Medieval Period.

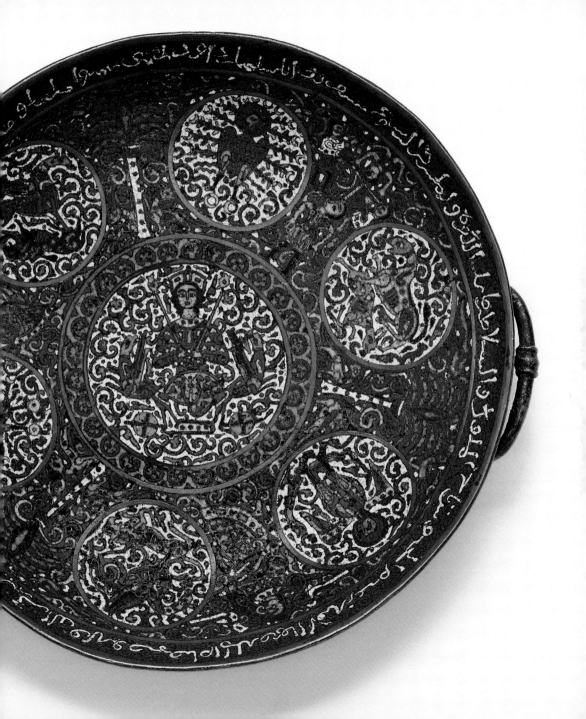

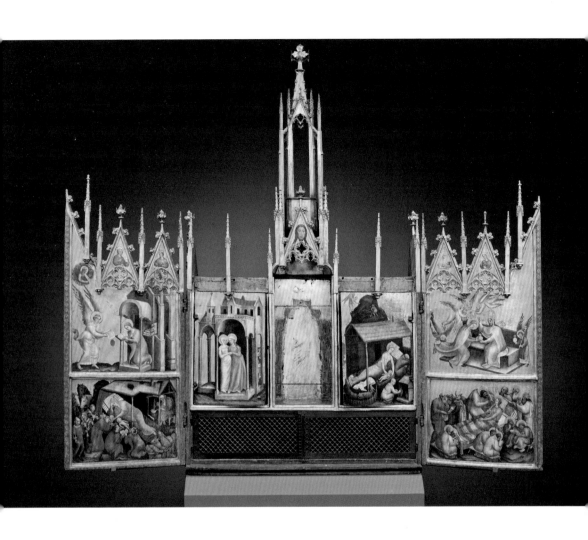

Altar of Schloss Tirol, c.1370–1373

Tempera and gold on wood, overall height (including tower): 249 cm, total width when open: 279 cm

Central shrine: 113 x 139 x 28 cm

Niche wings: each 64 x 43 cm

Side wings: each 68 x 69 cm

Tyrolean State Museums, Department of Art before 1900

Inv. no. Gem 1962

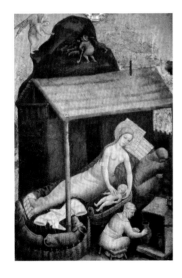

THE WORK KNOWN AS the Altar of Schloss Tirol is not only the oldest winged altarpiece in the Alpine region to have survived almost complete, but also a striking political symbol in the form of an artwork. The altarpiece was commissioned for the Saint Pancratius (Pancras) chapel in Schloss Tirol near Meran (Merano), the seat of the Counts of Tyrol, and displays both the Tyrolean eagle and the Austrian shield on the outer side of the wings. This work of art thus symbolises the political union of Tyrol and Austria that came about when the last Countess of Tyrol bequeathed the inheritance of her title to the house of Habsburg, resulting in the Princely County of Tyrol coming under Habsburg rule in 1363.

The name of the artist who created the altarpiece is unknown, but art historical analyses point to a knowledge of both Bohemian panel-painting and of the new artistic achievements of the Italian trecento following on from Giotto. We now assume that the artist who had received this training worked as a Viennese court painter.

This object is of particular interest not only from the historical point of view but also with regard to many of the details included in the series of images from the life of the Virgin Mary depicted in the interior of the altarpiece.

For instance, one of the Apostles present at Mary's death is wearing glasses – one of the earliest representations of these aids to vision in Europe. Also worthy of note are Mary's clearly visible, blue-and-white printed bedlinen and the extremely unusual depiction of St Joseph preparing a fortifying soup in the background of the scene of Jesus' birth.

GEORG VON PEUERBACH
Peuerbach 1423–1461 Vienna

Pocket sundial, 1451

Fire-gilded brass, 8 x 5.8 cm

Tyrolean State Museums, Department of History

Inv. no. AK U 5

GEORG VON PEUERBACH is one of the most famous mathematicians, astronomers and humanists of the fifteenth century. Although he died quite young, his career included teaching stints at various European universities. He earned his place in the history of natural sciences for his work on cosine law. His new ideas concerning this angular measurement made it possible to carry out the complex geopositioning calculations that were essential for longer voyages of discovery across the oceans of the world. The European discovery of America in 1492 would have been impossible without these new calculations.

Peuerbach was also employed in the service of Emperor Frederick III, for whom he created this pocket sundial, which is one of the earliest surviving portable sundials to have a magnetic declination indicator. This is a silk thread that stretches taut when the sundial is opened. The built-in compass is used to align the sundial to the north, and the shadow of the silk thread falls on the engraved scale which shows the true time by the sun at any given moment. This specialist technical instrument from the late Middle Ages was painstakingly crafted from fire-gilt cast brass.

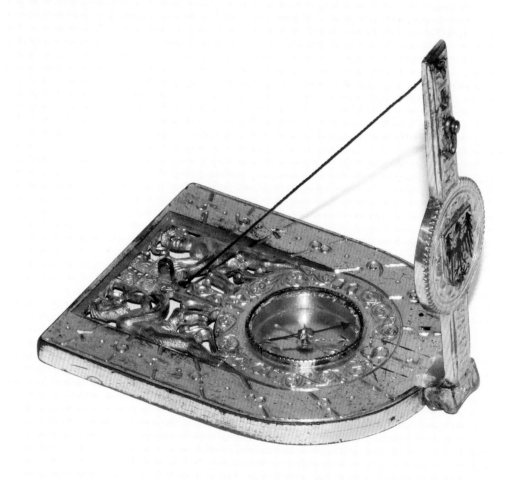

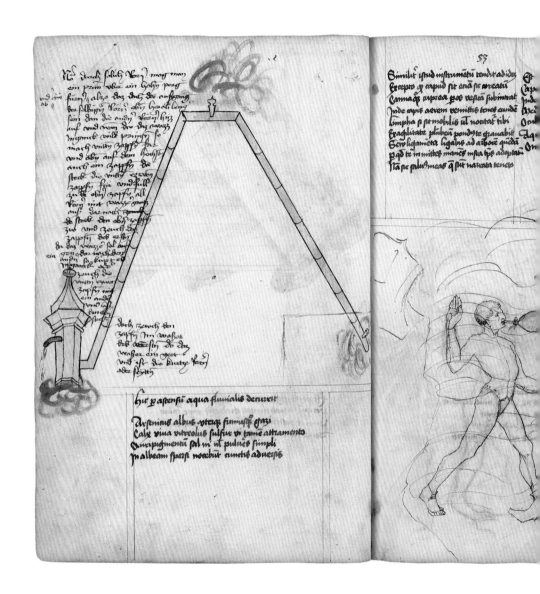

hic p artensu aqua fluuialis deriuat

Arsenicum albus ytera finuta gra...
Calx viua vitreolus sulfur vr fume attramentu
Auripigmentu sal m ut puluis simpli
m albeam spersit noiebit cunctis aduersis

Conrad Kyeser
Eichstätt 1366–after 1405 [?]

Bellifortis, c.1455

Medieval manuscript with pen and watercolour drawings, when open: 32 x 52 cm

Tyrolean State Museums, Library at the Ferdinandeum

Inv. no. FB 32009

In 1405, Conrad Kyeser completed his version of the *Bellifortis,* which was written for a courtly readership. The main intention of this important late-medieval book was to summarise the technical military knowledge of the age, which Kyeser had acquired as a soldier in the Bavarian army. The splendid manuscript is furnished with images illustrating a variety of weapons, such as crossbows, rockets and military vehicles. There are also technical drawings of mills and various kinds of hoisting equipment. The *Bellifortis* was thus the first illustrated book on the medieval European art of war and it had a lasting effect. The manuscript was created in an age characterised by the transition to firearms that permanently altered the techniques of warfare. However, despite all the technical detail of the descriptions, many omissions can be noted because, in his written descriptions, the author is more interested in the aesthetics of the rhyme scheme than in correct technical information.

The Innsbruck copy of the Eichstätt original can be dated by analysis of the watercolour drawings to around 1455 and was produced in Southern Germany. It is completely faithful to the original version in its structure and division into chapters, but there are numerous omissions in parts of the text and a few additions have been inserted later in another hand.

The detailed images in particular provide a true impression of the type of armour and the various military activities of a knight of the period. Nowadays at least 20 copies of Kyeser's *Bellifortis* from the mid-fifteenth century can be traced.

Banner of the Miners of Schwaz, 1499–1508

Oil on canvas, approx. 196 x 142 cm

Tyrolean State Museums, Department of History

Inv. no. AK Fahne 6

THE BANNER OF THE MINERS OF SCHWAZ is the oldest surviving Tyrolean banner. It is painted on both sides with the same motif. In the centre of each side is the Tyrolean eagle, which is still the coat of arms of the State of Tyrol. Surrounding this are the Austrian striped shield and the black eagle of the King of the Romans. Because of this interesting combination of coats of arms, the banner can be dated to the period before Maximilian I accepted the title of Emperor in 1508. To the left of the Tyrolean eagle is St George slaying the dragon and below him a kneeling miner. This display leads us to suppose that this banner is the battle standard of the Miners of Schwaz, who supported the then King Maximilian in the war against the Swiss. However, in the course of the restorations in 2009 and 2012 it became absolutely clear that, although the original creation of the substantially reworked object can be dated to around 1500, the image of the miner was not added until the beginning of the nineteenth century. This means that the banner is evidence of the special historical significance of mining in the Tyrol, in particular of the mines in Schwaz at the time of Emperor Maximilian. These mines were the reason for his financial investments and also one of the important factors motivating the particular attention he paid to the territory of the Tyrol.

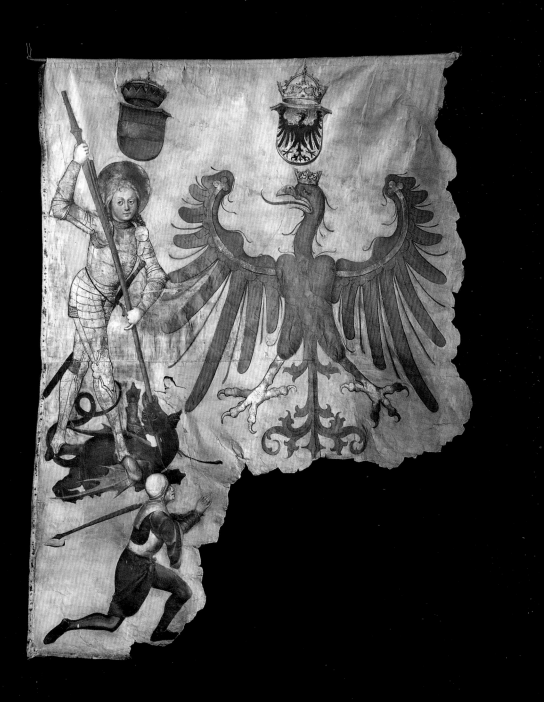

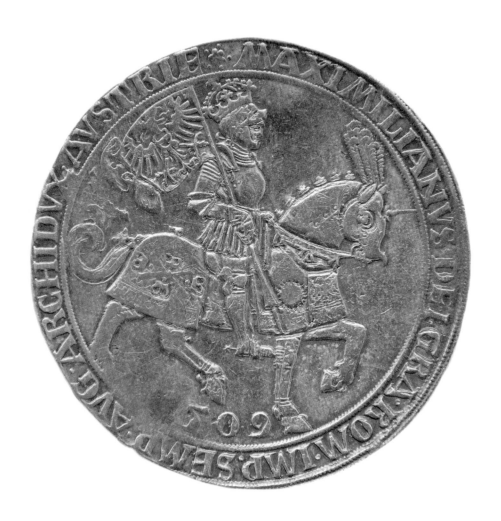

ULRICH URSENTALER
[?] 1482–1562 [?]

*Doppelschauguldiner (presentation coin) marking
Maximilian's acceptance of the title of Emperor, 1509*

Silver, 60.84 g

Tyrolean State Museums, Department of History

Inv. no. Mue 51

IN 1490, WHEN MAXIMILIAN I (1459–1519) succeeded Sigismund – who was nicknamed 'der Münzreiche', the 'rich in coin' – (1427–1496) as Archduke of Tyrol, he found a coinage system that was not only well ordered but also very progressive. The mint in the city of Hall, which mainly processed silver from the mines close to the town of Schwaz, was particularly important. The coins minted in Hall were accepted far beyond the territory of the Tyrol. Under Maximilian initial attempts were even made to conduct overseas trade using this Tyrolean silver. Spices from Asia were of particular interest here.

Because of its excellent tradition of craftsmanship, the Hall mint was able to produce very costly and artistically excellent coins. This special showpiece was commissioned by Emperor Maximilian after he accepted his imperial title in 1509. We even know the name of the artist who designed it: Ulrich Ursentaler. Maximilian had major difficulties in attending his coronation. The years of war with the Republic of Venice prevented him from travelling to Rome (Roma), and so his acceptance of the title of emperor took place in Trento.

The emperor is depicted on the medallion as a classical general on horseback, holding the imperial banner in his hands.

MARX REICHLICH
Brixen (Bressanone) c.1460/65–c.1520 Brixen (Bressanone)

Portrait of Gregor Angrer, Canon of Brixen, 1519

Oil on wood, 59.8 x 43.3 cm

Tyrolean State Museums, Department of Art before 1900

Inv. no. Gem 122

THE NAME OF THE SUBJECT, his high ecclesiastical office, his age and the year in which this portrait was painted are noted in the form of a succinct inscription on a panel at the lower edge of this picture. Every detail of the face, clothing and headgear of Gregor Angrer, the Canon of Brixen, is captured with great precision. His gaze is directed straight at the viewer, yet goes above and beyond him. The dominating inscription is attached to a kind of parapet in front of the figure. This clever compositional solution further increases the illusion of realism in the portrayal.

Such qualities point to an artist who has been exposed to both the traditions of Northern Italian renaissance painting and German painting of the circle of Albrecht Dürer and has studied the innovations brought in by the latter. Today it is generally agreed that the South-Tyrolean painter Marx Reichlich, a pupil of Friedrich Pacher who worked closely with Michael Pacher, can be seen as such a figure and the creator of this portrait. Together with the Pacher family of artists, he was active not only in his homeland but also in the prince-archbishopric of Salzburg.

Portraits like these also hint at a close study of Roman tombstones, where portrait busts of the deceased are often found in combination with a large biographical inscription.

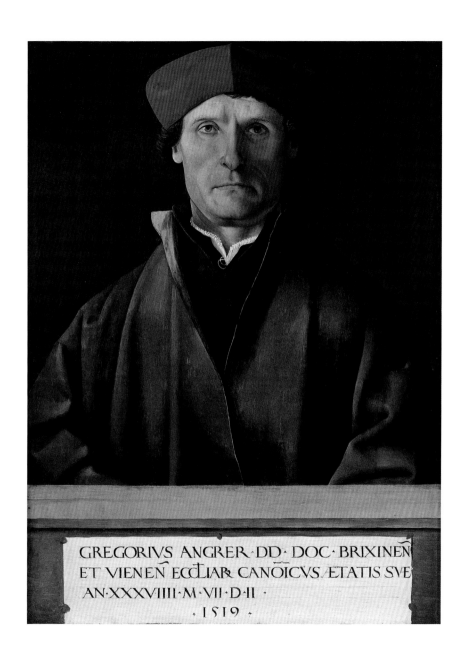

GREGORIVS ANGRER · DD · DOC · BRIXINEN
ET VIENEN ECCLIAR CANOICVS ÆTATIS SVE
AN · XXXVIIII · M · VII · D · II ·
· 1519 ·

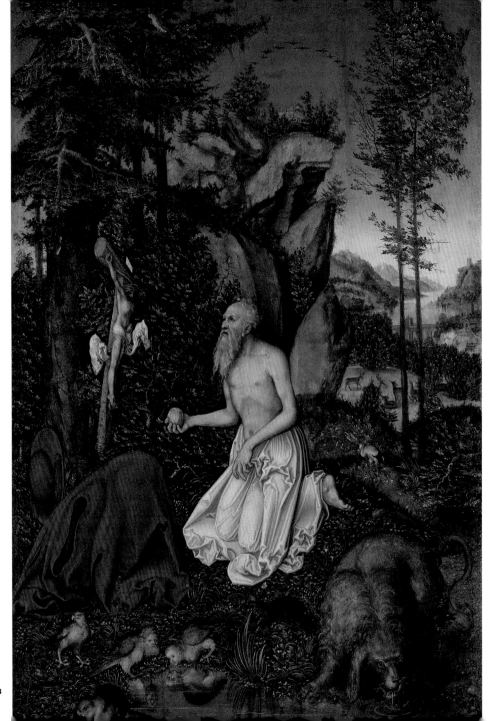

Lucas Cranach the Elder
Kronach c.1472–1553 Weimar

St Jerome, c.1525

Tempera on wood, 89.8 x 66.9 cm

Tyrolean State Museums, Department of Art before 1900

Inv.no. Gem 116

Lucas Cranach the Elder was much preoccupied with this subject, though the present version represents the last surviving version. St Jerome, one of the four great Doctors of the Church, is not shown as he so often is in a scholar's study or in his legendary refuge of a cave, but out in the open countryside. This is depicted in fine detail, allowing the individual animals and plants to be easily identified. In addition to the traditional lion, the saint's attribute animal, extremely exotic creatures are also represented. This early painting surprises by including animal species from the New World that had been discovered only a few years before. Also worthy of note is the nuanced depiction of the landscape, in which the artist makes brilliant use of colour perspective, applying differentiated tones of blue in the background areas to create a sense of depth in the eye of the viewer.

The saint's meditation before a crucifix is bound up in a scholarly view of the world that is dedicated to analytical differentiation. The great significance of the saint in these decades of intense religious debate is reflected in the fact that Martin Luther described him as his most important theological reference point. However, Cranach also painted one of the most prominent Catholic miraculous images, the famous devotional image *Mariahilf* (1537), which is now in the Cathedral of St James in Innsbruck and one of the most frequently copied depictions of the Virgin Mary in Central Europe.

HANS POLHAIMER THE ELDER
Munich c.1490/1500–1566 Innsbruck [?]

***Preliminary drawing for the Statue of Godfrey of Bouillon
on the tomb of Emperor Maximilian I in the Hofkirche in
Innsbruck***, c.1530–1532

Pen in grey-brown ink and watercolour on paper, 29.7 x 21 cm

Tyrolean State Museums, Department of Prints and Drawings

Inv. no. AD 32

THE LAVISHLY DESIGNED tomb of Emperor Maximilian, now in
the Court Church in Innsbruck, is one of the largest tombs of any
monarch in Europe. The 28 over-life-sized bronze figures represent
the real, yet also idealised, family tree of Maximilian I, who subse-
quently raised the house of Habsburg to European status through
his extensive marriage policy. The dark patina of the bronze figures
resulted in the Innsbruck Court Church being given the local nick-
name of Schwarzmanderkirche (black men's church). Emperor
Maximilian started the work on his tomb during his lifetime, though
he had intended it to be in the Georgskapelle in Wiener Neustadt.
Maximilian's grandson Ferdinand I brought his grandfather's work
to completion and had the tomb placed in the newly erected Court
Church in Innsbruck, as part of the Franciscan monastery establis-
hed next to the imperial palace, the Hofburg.

Compared with the preliminary drawing shown here, the
massive bronze statue of Godfrey of Bouillon is much simpler in
execution, but still wears the symbolic crown of thorns of Christ.

Depicted here as a crusader with such attributes as the Arma
Christi (the weapons of Christ or the instruments of the Passion),
Godfrey stands as a role model for Maximilian, who had earned the
byname of 'the last knight'. There is a further connection in that
Godfrey was the first ruler of the Kingdom of Jerusalem (1099–1100)
and the title of 'King of Jerusalem' was later claimed by the house
of Habsburg, as Maximilian's marriage to Mary of Burgundy had
made him co-ruler of her lands, which were then inherited by their
descendants. The disputed claims arising from this marriage were
the start of centuries of conflict with France but, having acquired
it again by a different route, the Habsburgs continued to use the
ceremonial title of King of Jerusalem well into the twentieth century.

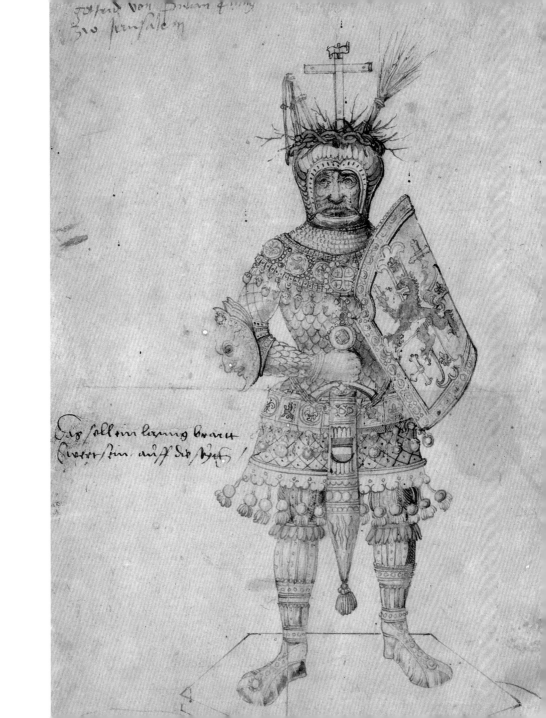

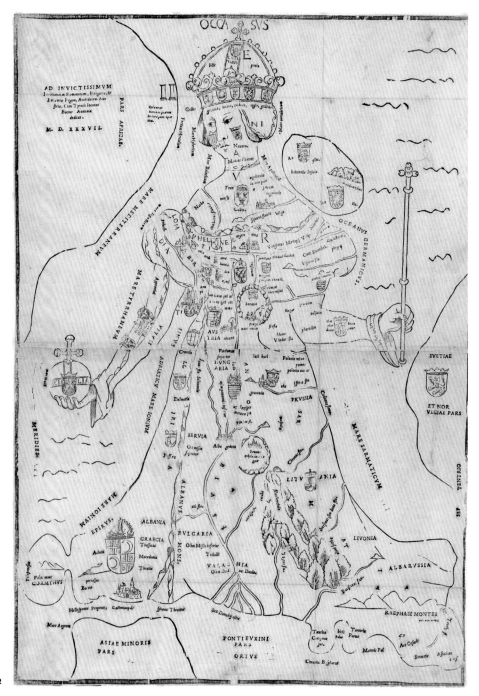

32

JOHANNES PUTSCH
[?] 1516–1542 [?]

Europe in the Form of a Queen (Europa Regina), 1537

Woodcut, 63 × 44 cm

Tyrolean State Museums, Department of History

Inv. no. K 5 84

THIS SYMBOLIC MAP of the continent of Europe in the form of a crowned female figure is a perfect example of a Mannerist display piece from a cabinet of curiosities of this period. It was created as a woodcut in 1537 by the Innsbruck poet and courtier Johannes Putsch. This 'Europa Regina' is one of the oldest symbolic maps in the form of humans or animals. Here Europe is represented as the body of a queen, with France at her bosom and the Holy Roman Empire at her heart. Classic symbols of imperial power, such as the crown, the sceptre and the orb, complete the shape of the body.

The body as a unit depicts the continent of Europe as an integrated European system; the imperial insignia suggest the special status of this continent in the hierarchy of power in the world view of the time. One point of interest is the fact that there are no borders drawn inside the continent. Innsbruck, the home city of the mapmaker, is schematically reproduced. This map is also the first to show the name Tyrol.

JACQUES DE GHEYN II
Antwerp 1565–1629 The Hague
or DIRCK DE VRIES (attributed)
Netherlands c.1550–c.1595 Netherlands

Portrait of a Draughtsman, c.1600

Pen and grey-brown ink on paper, 12.7 x 10.8 cm
Tyrolean State Museums, Department of Prints and Drawings
Inv. no. NL 83

THE AUTHORSHIP OF this interesting drawing is still a mystery
and the subject of ongoing academic debate. Stylistically the dra-
wing suggests Dutch art of around 1600. Here Jacques de Gheyn II
and Dirck de Vries are mentioned as possible names for the artist.

The draughtsman in the picture is in intense eye contact with
the viewer of the drawing, creating the impression that he was
engaged in drawing the latter's portrait. It is notable that he is dra-
wing with his left hand. However, it is quite likely that this picture
is a preparatory drawing for a print, in which the sides would be
reversed during reproduction.

The artist drawing with a pen is totally concentrated on the
processes of observation and artistic creation; even today's viewer
finds it hard to escape from his intense gaze.

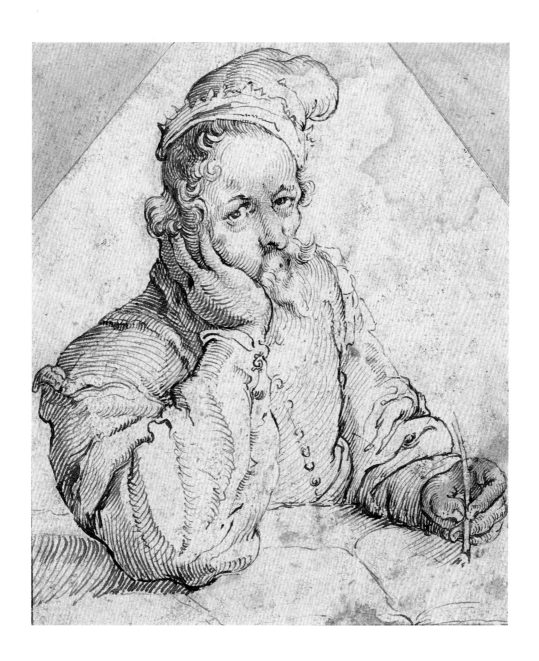

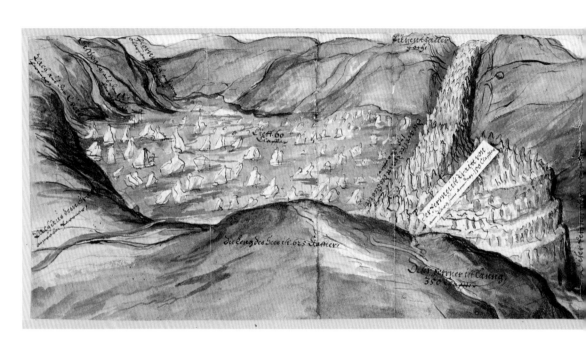

ABRAHAM JÄGER (ATTRIBUTED) [?]

Rofaner Eissee – oldest known depiction of an Alpine glacier, 1601

Watercolour, 19.5 x 52 cm

Tyrolean State Museums, Library at the Ferdinandeum

Class. no. FB 7218

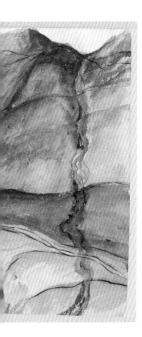

THIS WATERCOLOUR FROM 1601 is the oldest known depiction of an Alpine glacier. It shows an ice-dammed lake in the Tyrolean Ötztal, shortly before the water burst through. After the great lake at Vernagt in the Rofental broke through the ice barrier on 16 June 1600, causing widespread damage in the entire Ötztal, Abraham Jäger was commissioned on the authority of the Hofbauschreiber to draw up an appropriate description and report. When he went to the Vernagtferner glacier in 1601, he described not only the lake that had burst through the ice dam but also conveyed the state of the area in this watercolour. The situation he found is easily recognisable: the ice had created a dam on the Zwerchwand, and a lake with an impressive length of about 1,200 m, a width of about 120 m and a depth of some 10 m had formed behind it. The spectacle of nature he describes here, which was also described elsewhere, is thus particularly well documented. Unfortunately, despite many prayers and supplicatory processions being organised, the eruption of the lake and the subsequent flooding could not be prevented.

This image is one of the many unusual and surprisingly high-quality documents to be found in the extensive library of the Tyrolean State Museums. This collection has attracted great attention ever since the foundation of this institution in 1823.

HIPPOLYT GUARINONI (HIPPOLYTUS GUARINONIUS)
Trento 1571–1654 Hall in Tirol

Herbarium, 1610–1630

Book with wooden cover and leather fastening straps, 106 pages, 33 x 21 cm

Tyrolean State Museums, Department of Natural History

Inv. no. Botanik, 01

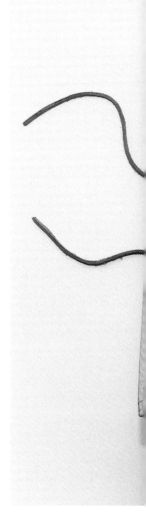

THIS HERBAL IS THE oldest surviving herbarium compiled on the soil of present-day Austria. Hippolyt Guarinoni, who was active as a Stiftsarzt (convent physician) in Hall in Tirol, spent many years working on it. It contains 633 dried and pressed plants, each of which is furnished with a German and a Latin name. Unlike other historic herbals, it has no decorative borders and was therefore not so much an impressive compilation as a reference book intended for specialist use. This is borne out by an index compiled by the author himself that enables plant specimens to be quickly found and compared.

This herbarium is an extremely valuable document that gives us an insight into the regional flora that existed in the early seventeenth century. At the same time, it allows us to get to know how plants were identified before the system of botanical nomenclature formalised by Carl von Linné (Linnaeus) (1707–1778) that is still in use today. It is also a storehouse of many interesting folk names for plants. Changes in the local vegetation can be observed as well as traditional ways in which they were used in the past. Species that have now died out in the Tyrol, for instance the bee orchid, can be found in this book. In addition, 40 food and ornamental plants provide a glimpse of horticulture in those times.

The fascinating variety of this herbal reflects the wide diversity of interests of the scholar Hippolyt Guarinoni, who was active in many fields. The church of Volders near Innsbruck, which he founded and for which he produced the first architectural plan, remains a striking example of his versatility.

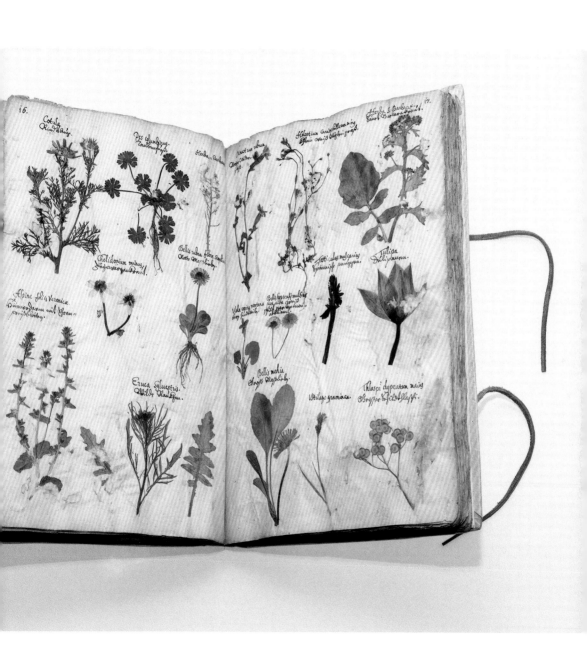

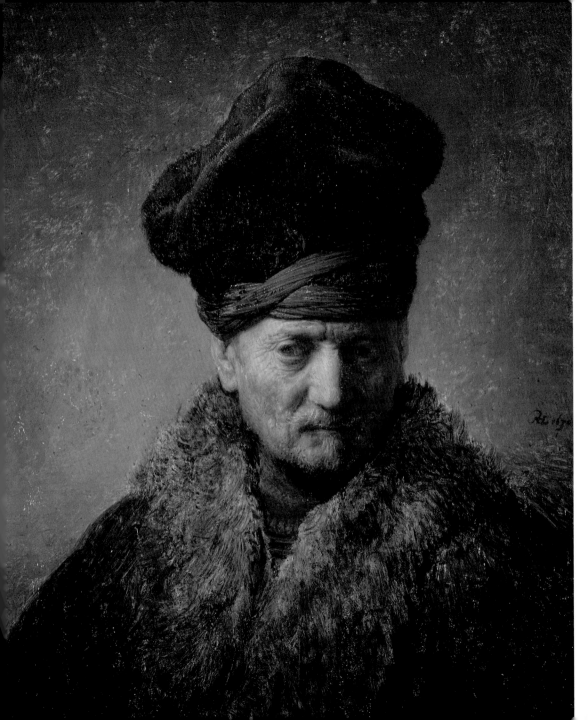

Rembrandt Van Rijn
Leiden 1606–1669 Amsterdam

Old Man with a Fur Hat, 1630

Oil on wood, 22 x 17.5 cm

Tyrolean State Museums, Department of Art before 1900

Inv. no. Gem 599

For centuries Rembrandt's characteristic chiaroscuro painting left its mark on very different generations of artists and made him undoubtedly one of the most famous personalities in the history of European art. The present painting, which came to the Tiroler Landesmuseum Ferdinandeum as part of a donation of an extensive collection of Dutch art, also bears witness to his special qualities as a painter. Although there was discussion in earlier years as to whether it was possibly a portrait of his father – who died in the year the picture was painted – today, this small-format painting on wood is seen as more likely to be a study of a character head for use if required in larger pictorial compositions. The old man, depicted here in meticulous and extremely sympathetic detail, wears a kalpak, a high-crowned fur cap worn by Polish Jews, probably thus indicating the Jewish-influenced circle surrounding the artist in his early years, when he had just established himself as an independent painter and was celebrating the first successes that eventually led to his move from Leiden to Amsterdam.

The extensive Rembrandt Research Project, in which the authenticity of many of the artist's traditional works is agreed or denied, has confirmed the place of this sensitive character head in the master's oeuvre and made it possible once more to study his confident artistic hand in the creation of the finest nuances of individual effects of light.

Bernardo Strozzi
Genoa (Genova) 1581–1644 Venice (Venezia)

Portrait of Claudio Monteverdi, c.1630

Oil on canvas, 84 x 70.5 cm

Tyrolean State Museums, Department of Art before 1900

Inv. no. Gem 503

This painting is the only confirmed portrait of the court musician and composer Claudio Monteverdi (1567–1643). The career of this exceptional musician unfolded mainly at the court of the ruling Gonzaga family in Mantua (Mantova). He began his career as a simple viola da gamba player and eventually worked his way up to become director of music at this ducal court, which was famous throughout Europe for its splendid cultural life. In this post he was responsible for the entire lavish programme of both spiritual and secular music in the Palazzo Ducale in Mantua (Mantova). The composer achieved popular significance with his commissioned opera *Orfeo*, which is still widely considered to be one of the earliest examples of this new theatrical format. When the libretto of this opera was printed, it quickly spread throughout Europe. Monteverdi also introduced various innovations in church music and madrigal-writing that had a lasting influence on the history of music. In 1613 he became *maestro di capella* at St Mark's cathedral in Venice (Venezia) and, despite his many travels, this city was to be his main place of residence until the end of his life.

It was also in this city that the Venetian artist Bernardo Strozzi painted the portrait, which shows Monteverdi dressed in black with white collar and cuffs, the typical costume of the time. In his hands he holds a music book, giving the viewer a clear indication of his profession. The dark background and the appropriate clothing of the sitter concentrate all the attention on his face and his intense gaze.

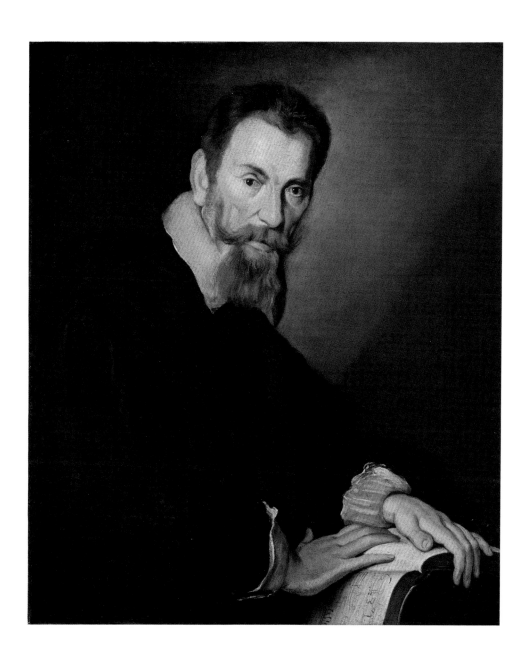

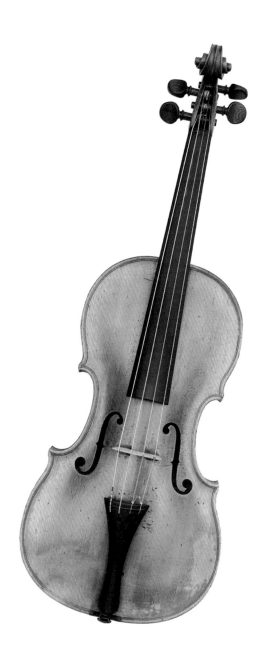

JAKOB STAINER
Absam 1619–1683 Absam

Violin, 1682

Belly spruce, back and ribs maple, fingerboard ebony
Overall length: 58.4 cm, max. width: 20.2 cm, height of ribs: 3–3.1 cm
Tyrolean State Museums, Department of Music
Inv.no. M I 230

THIS VIOLIN BY Jakob Stainer originally came from the Servite monastery in Innsbruck and is considered to be one of the most beautiful surviving instruments by the famous Tyrolean maker. It is also his latest dated work and is therefore surrounded by the aura of the *opus ultimum*. Although this instrument was converted in the nineteenth century to adapt it to the new demands of contemporary musical techniques, the exceptional quality of the craftsmanship and the perfect proportions are still recognisably from the masterly hand of Stainer. As the first maker of violins outside Italy, Stainer followed the example of Nicola Amati from Cremona and used a 'mould' – a kind of template used in the making of quality instruments. This technique came into general use after that time, so that Stainer's instruments were seen as models throughout Europe. Alongside those of the great violin makers from Cremona, Jakob Stainer's original creations are among the most sought-after instruments in the history of European music. The Department of Music of the Tyrolean State Museums has five instruments that are indisputably by his hand, including not only the world-famous violins but also two violas and a viola da gamba.

Towel-holder (Vanitas), 2nd half 17th century

Wood, carved and mounted, 51 x 41.5 x 28 cm

Tyrolean State Museums, Museum of Tyrolean Regional Heritage

Inv.no. F 289

THE ARTISTICALLY DESIGNED, admonitory reminder of human death in European Baroque culture – known as a *memento mori* – can occasionally take very dramatic forms.

In this carved towel-holder, the right side of the figure is devoted to worldly beauty in the shape of a magnificently dressed and bejewelled young lady wearing a crown, while the left side represents death in the form of a human skeleton. These two existential physical human forms are directly connected to one another. A further element of connection, yet also of transformation, is the young queen's large string of pearls, which becomes a snake on the side with the human skeleton. This snake is a symbolic reference to the original sin of humankind: its disobedience to God's commandments in the biblical story of the Creation. The snake's head is also placed close to the human heart to give symbolic expression to the gnawing pangs of conscience.

This brutal reference in concise artistic form to the transience of human life and all its vanity originates from a country house close to Innsbruck.

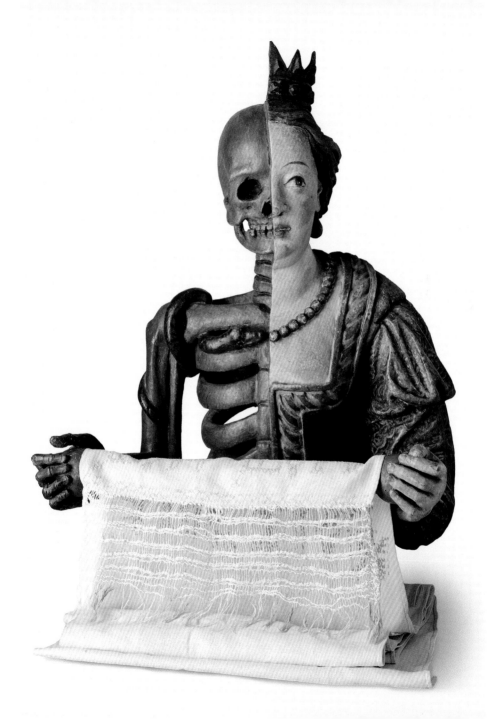

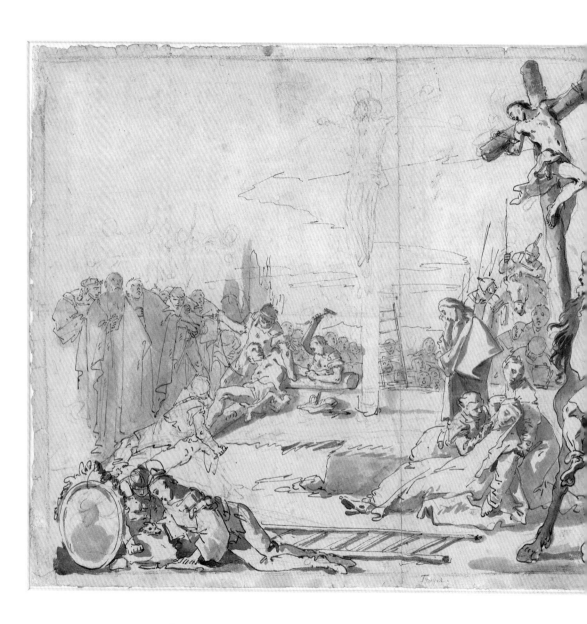

Giambattista Tiepolo
Venice (Venezia) 1696–1770 Madrid

The Hill of Calvary, c.1722–1725

Pen and dark grey ink and brush in grey ink over charcoal on paper, 38.7 x 53.9 cm

Tyrolean State Museums, Department of Prints and Drawings

Inv. no. Ital 541

Beginning in Venice (Venezia), Giambattista Tiepolo succeeded in building a great European artistic career. Although his first commissions were in the area around his native city, his career subsequently led him to Germany and Spain. The decoration of the Würzburg Residence is still considered to be his major work; the fresco he painted in 1752/53 on the vault above the staircase is the largest continuous ceiling fresco of the period. The frescoes in the Villa Valmerana near Vicenza also document his special talent for creating artistic settings in large and small formats.

This drawing comes from the artist's early years and is associatedwith the altarpiece for the Capella di Santa Barbara in the church of San Martino on Burano – one of the islands in the Venetian lagoon. With a light and confident touch the artist presents a theatrically designed crucifixion scene, in which intensely emotional elements, such as the enormous brutality of the event, intimate sorrows and cautious contemplation combine dramatically to form a fascinating whole. Already included in the preparatory sketch, in the bottom left of the picture is a framed medallion with the portrait of the man who commissioned the altarpiece – an interesting solution in the form of a picture within a picture. The artist subsequently altered his sketch in several places, for instance the dominant equestrian figure at the right-hand edge of the preliminary drawing was replaced by a standing male figure that is traditionally said to have the face of the artist.

Rosalba Carriera
Venice (Venezia) 1675–1757 Venice (Venezia)

Portrait of a Lady, c.1730

Pastel on paper, mounted on canvas, 43.2 x 34.8 cm
Tyrolean State Museums, Department of Art before 1900
Inv. no. Gem 1127

The Venetian artist Rosalba Carriera, who specialised in elegant, sensitive portraits, was extremely successful and much in demand at the courts of Europe. She drew these portraits in pastels, giving them a subtle, paint-like effect. Although the early years of her artistic activity were characterised by constant travel to the European courts, in the second half of her life she returned ever more frequently to Venice (Venezia). At first her studio in this city functioned as a kind of fixed point on the aristocratic Grand Tour of Europe, but a progressive eye disease made artistic work increasingly difficult for her. From 1746 she became completely blind and finally died impoverished and deserted. The fashionable world of aristocratic splendour, the refinement of late Baroque court culture, and not least the aggressive display of wealth so brilliantly depicted by the artist, are thus in stark contrast to her own life.

This portrait of a lady is an example of the typical subjects that brought the artist her success. An extravagantly dressed young woman, probably a noble lady or an actress, is just putting the finishing touches to her toilette. Her elegantly posed left hand holds a pearl earring whose matt shimmer is a most charming complement with the delicate colour of her skin.

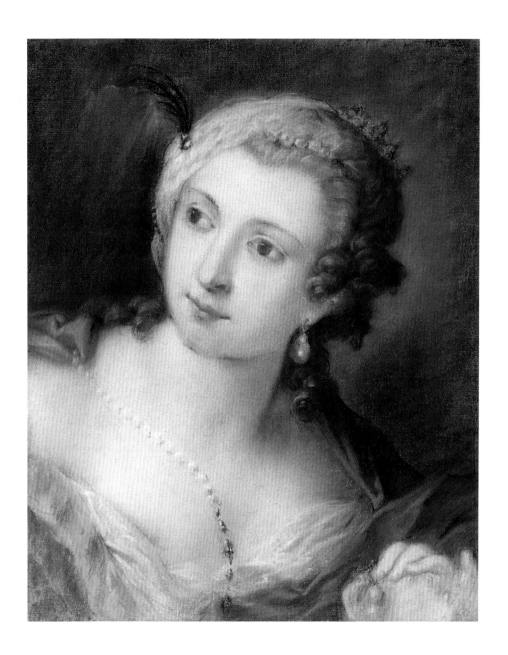

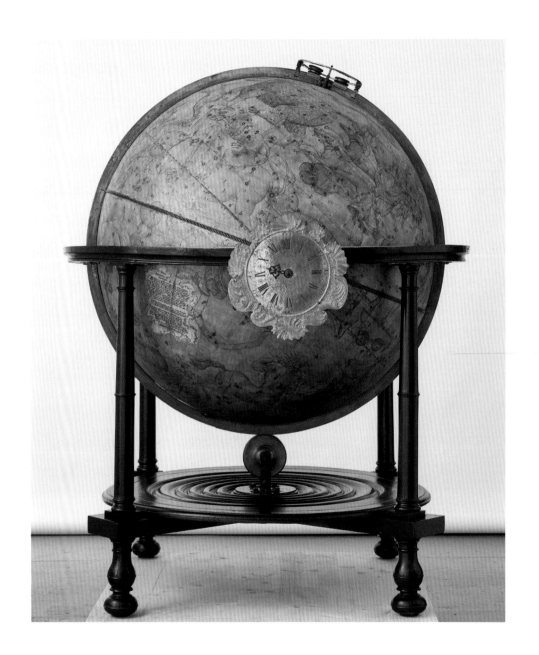

Peter Anich
Oberperfuss 1723–1766 Oberperfuss

The Great Celestial Globe, 1755/56

Turned wood, ink on paper, diameter (globe): 100 cm, overall height: 151.5 cm

Tyrolean State Museums, Department of History

Inv. no. Glo 1

Peter Anich was a simple farmer's boy from Oberperfuss near Innsbruck and became one of the most important cartographers of the eighteenth century. He was already 28 years old when he received an education in mathematics, practical geometry, mechanics and astronomy that suited his particular talents. Astonishingly, he had already shown his outstanding gift for astronomical observations and calculations in his youth. After completing his education in Innsbruck he was immediately commissioned to draw an extensive series of maps of the Tyrol. The accuracy of the detail of this project astounded international experts and he received numerous honours from official bodies, including an honorary pension. Sadly Peter Anich was unable to benefit from this pension, as he died young.

During the period of his education in Innsbruck, Anich was already working on a large celestial globe in 1755/56 and a terrestrial globe between 1757 and 1759. Built into the celestial globe is a complex clockwork mechanism that turns it on its axis once a day. The dial includes the indicative inscription 'A peasant drew near to the stars of the universe'.

Cupboard, Wipptal or Stubaital, 1777

Spruce, painted, 124 x 182 x 57 cm

Tyrolean State Museums, Museum of Tyrolean Regional Heritage

Inv. no. 10148

THIS KIND OF COLOURFULLY painted furniture from the Tyrol was long stereotypically described as 'Zillertaler Furniture', even though the family name Eller seen on the upper part of the cupboard points to the wider area around Innsbruck. The general description of 'farmhouse furniture' does not suit the cultural reality of the eighteenth century either, as the excellent craftsmanship of the decorative painting points to a slightly higher social class that could afford such extravagantly fashioned pieces of furniture. The design of this cupboard, which was probably a wedding gift, imitates the painting and the wooden elements of the grand furniture of the Baroque. The portrayal of the Virgin Mary at the centre of the ornamental top is especially noteworthy. It is a version of an image known as 'Our Lady of Good Counsel' that is said to have travelled miraculously from Albania to the town of Genazzano near Rome (Roma) in the late Middle Ages. In the course of the intensive efforts of the Catholic Church to encourage the traditional pilgrimage and the worship of saints, thousands of copies of this image of the Madonna were distributed throughout Europe. In 1775 the Tyrolean abbey of Stams received a copy of this image of the Madonna lovingly embracing the Christ child and gazing intently into his eyes. Pilgrimages to this miraculous painting in Stams Abbey also became popular, and the image became widespread once again and was even found on furniture, as can be seen here.

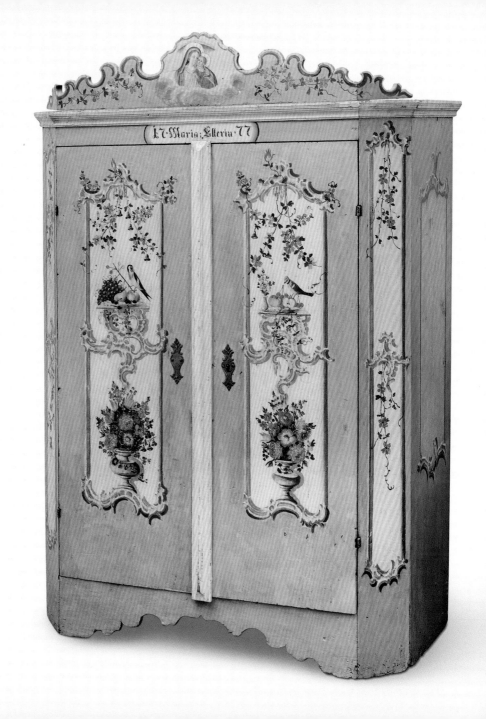

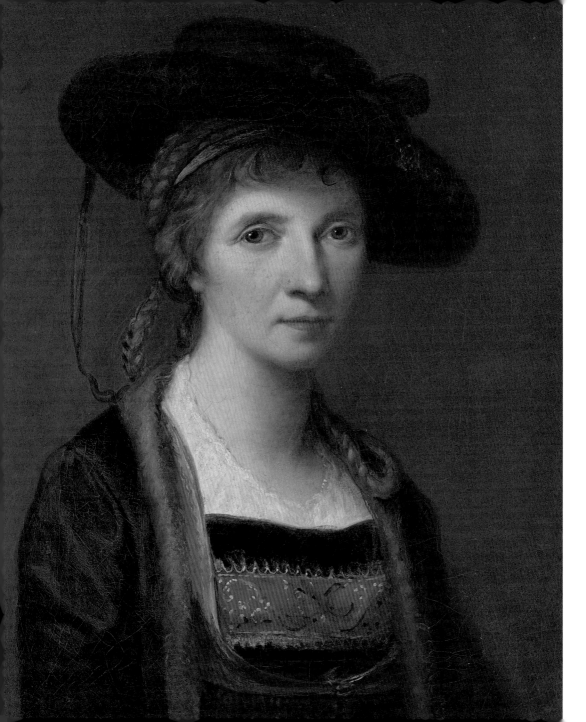

ANGELICA KAUFFMANN
Chur 1741–1807 Rome (Roma)

Self portrait in traditional Bregenzerwald Costume, 1781

Oil on canvas, 61.4 x 59.2 cm

Tyrolean State Museums, Department of Art before 1900

Inv. no. Gem 301

ANGELICA KAUFFMANN can be described as a kind of female superstar in the art scene of European classicism. As a sophisticated woman of the world she lived mainly in Rome (Roma) and London and made her way to the centre of learned, art-loving salons in both cities. For example, in his *Italian Journey*, his account of his travels in Italy, Goethe gives a very vivid report of the great influence exercised by this highly educated woman who had such a successful career as a painter. No less importantly, she was also one of the founder members of the Royal Academy of Arts in London. She was something of a child prodigy as a painter, winning people over at a very early age, especially with her portraits, and she painted her first self portrait at the age of twelve.

This self portrait of the artist, dating from the time of her great triumphs in Italy, is even more astonishing. In it she portrays herself as very definitely a country girl in the traditional costume of the Bregenzerwald, the region where her father's family originated. She herself had lived in this region for only a very short period in her youth, as she spent most of those years travelling with her artist father on his assignments. This picture was painted at the time of her marriage to her second husband, the Venetian painter Antonio Zucchi (1726–1795), and also the time when her father died, so maybe it should be interpreted in the context of these events.

Coloured song sheet
(Song of the Tyroleans for Emperor Francis I), 1816

Mixed techniques, 4 sides, c.19.8 x 16.4 cm

Tyrolean State Museums, Tyrolean Folk Song Archive

Inv. no. 147

THIS SONG SHEET from the collection of the Tyrolean Folk Song Archive dates from 1816 and must be considered a great rarity, as it is a unique hymn to the loving attachment of the Tyrolese to the house of Habsburg and especially for Emperor Francis I. As the dating shows, the text of this song and the extravagant design of the title page were created in 1816 – shortly after the Congress of Vienna and a few years after the Tyrolean rebellion against Napoleon's occupying forces in 1809 led by Andreas Hofer. This documentation of the warmth of the close relationship between the Tyrol and the Habsburgs is remarkable, because the Tyrolean rebellion of 1809 had taken place against the political wishes of the Habsburg monarchy. Although the Imperial house acknowledged the brief military successes of the Tyrolese with guarded pleasure, the Tyrol was returned to the Napoleonic coalition immediately after the loss of the battle of Wagram, even though the emperor had confirmed in writing his steadfast attachment to his Tyrolean lands just a short time previously.

After the end of Napoleon's military successes, Europe was reorganised at the Vienna Congress of 1814/15 and the Tyrol once again came under the rule of the house of Habsburg. In the meantime, Emperor Francis had established the Austrian Empire in 1804, and two years later declared the end of the Holy Roman Empire. In succinct form, the title page of the song sheet shows the Austrian imperial double eagle, and below it two men in festive Tyrolean costume, one holding a flail and the other a hayfork and each with a symbolic heart in his right hand, expressing their love for the emperor.

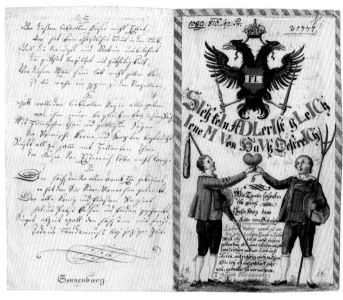

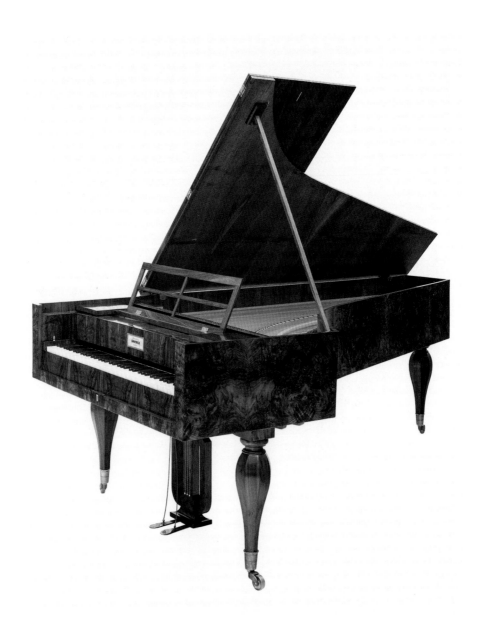

JOHANN GEORG GRÖBER
Pettneu 1775–1849 Innsbruck

Fortepiano, c.1830

Walnut veneer (outside of rim burr walnut), underbody spruce, white keys covered in bone, black keys ebony, 2 pedals (damper, moderator), range 6 ½ octaves, overall length: 233 cm, width: 124.6 cm, carcass height: 31.5 cm, overall height: 89 cm

Tyrolean State Museums, Department of Music

Inv. no. M I 271

JOHANN GEORG GRÖBER was the most important Tyrolean piano maker of the first half of the nineteenth century. He learned his craft in Vienna and clung to the principles of Viennese piano-building throughout his life. His pianos have the Viennese mechanism, also known as the Prellzungenmechanik, following the example of Johann Andreas Stein. In this complex mechanism, the string is not only gently struck by a small hammer but the damper above falls back onto the string immediately, muffling the sound.

Nowadays pianos by Johann Georg Gröber can be found in the most important collections of musical instruments throughout the world and are distinguished by the high quality of their sound and their craftsmanship. Gröber's pianos set new standards, especially in the selection and handling of the various woods used. This is also true of this fortepiano, which has recently been completely restored and is regularly played as part of the museum's special music programme.

JOSEF BENEDIKT PROBST
Sterzing (Vipiteno) 1773–1861 Innsbruck

Crib, 1840

Glass, wood, 78 x 110 x 38 cm
Tyrolean State Museums, Museum of Tyrolean Regional Heritage
Inv. no. 20796

AMONG THE MOST POPULAR traditional objects of the Alpine region today are the sometimes over-extravagant Christmas cribs. In addition to the central presentation of the adoration of the new-born son of God, first by the chosen shepherds, then by the three kings as representatives of all humanity, these scenes contain many supplementary single figures and groups. Thus the entire reality of everyday life is brought to the Christ Child. Christmas cribs come in a wide variety of materials, dimensions and formal language. In the Tyrol area it is particularly the wealth of detail in the carved and painted wooden figures that arouses astonishment.

The crib shown here was created in around 1840 by the Tyrolese Josef Benedikt Probst. Numerous individual figures and architectural elements are gathered together in the narrowest of spaces. The special value of this crib is partly expressed in the fact that it was set in an extravagantly designed empire glass case. It not only shows the birth of Christ as the central scene, but also offers an overview of biblical events, from the Fall of Man and the subsequent expulsion from Paradise, to the Resurrection of Christ and His Ascension into heaven. Although it was designed as a prestigious ecclesiastical showpiece, this series of theatrically sculptural scenes also marks the transition to the popular traditional crib.

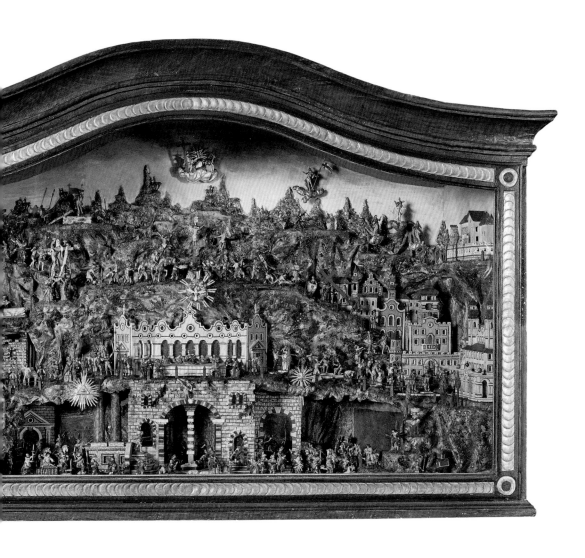

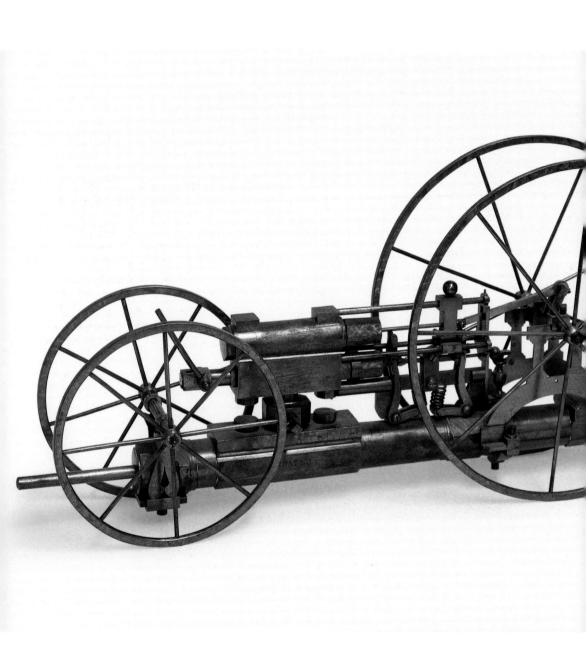

JOHANN KRAVOGL
Lana 1823–1889 Brixen (Bressanone)

Model of a compressed air locomotive, 1844

Iron and brass, 47.5 x 8.7 x 20.3 cm

Tyrolean State Museums, Department of History

Inv. no. Technik 6 227

IN THE TECHNICAL COLLECTIONS of many museums there are countless amazing items that show widely differing views of the development of human cultural history in an interesting way. This is often a matter of alternative ideas for technical devices that failed to catch on over the course of history – usually for financial reasons.

That is the case with this model of a compressed air locomotive built by the inventor Johann Kravogl. It is fully functional and dates from 1844, the age when the development of the steam engine had just begun.

The Tyrolese inventor made a name for himself with many other technical achievements. Among other things, he developed a new type of vacuum pump, a lithographic press, a precision balance, an electric bell, and high-voltage power capacitors. His inventions also include an electrically powered motorcycle. Despite the great innovative importance of many of his inventions, he did not derive any particular financial benefit from them, although they did bring him the wonderful title of 'KK Universitätsmechaniker' ('University Mechanic of the Dual Monarchy').

The model is in the form of a small four-wheeled cart and was set in motion by means of a piston air pump. The compressed air locomotive is set in motion by the force of the air when allowed to expand. Kravogl did not have access to any form of higher technical education when he was developing this locomotive. It was his first invention, bearing witness to his special technical talent.

Gustav Klimt
Baumgarten, Vienna 1862–1918 Vienna

Portrait of Josef Pembaur, 1890

Oil on canvas, 68.4 x 55.4 cm

Tyrolean State Museums, Department of Modern Art

Inv. no. Gem 1213

Along with those of the Viennese actor Josef Lewinski and the composer Franz Schubert, this portrait of the Innsbruck composer and director of music Josef Pembaur (1848–1923) is one of the very few male portraits painted by Gustav Klimt. Although the portrait of the musician is extremely naturalistic, the other elements of the composition should be considered as ornamental symbolist additions or even exaggeration. Klimt integrates a broad golden frame into the overall composition, thus taking his first characteristic step towards the style of the Secessionist movement for which he was to become famous in the years that followed.

The almost photo-realistic portrait of Pembaur is scattered with an assortment of ornamental and symbolic shapes, making it almost a speaking image, since these symbols clearly indicate Pembaur's post as a musician. They include, for example, the ancient musical instrument, the lyre, which can be seen both in the background of the picture and on the painted frame. In the broadest sense, the ornamental symbols are quotations from a Hellenistic culture of the kind very frequently found in European art of the Symbolist movement. Klimt probably received the commission for the portrait in 1889 through the Viennese actor Georg Reimers, who was one of the co-founders of a Pembaur Society in Vienna.

The special connection between the portrait and the heavily symbolic ornamentation that is reminiscent of the Jugendstil makes the painting a key step in the development of Gustav Klimt's creative output.

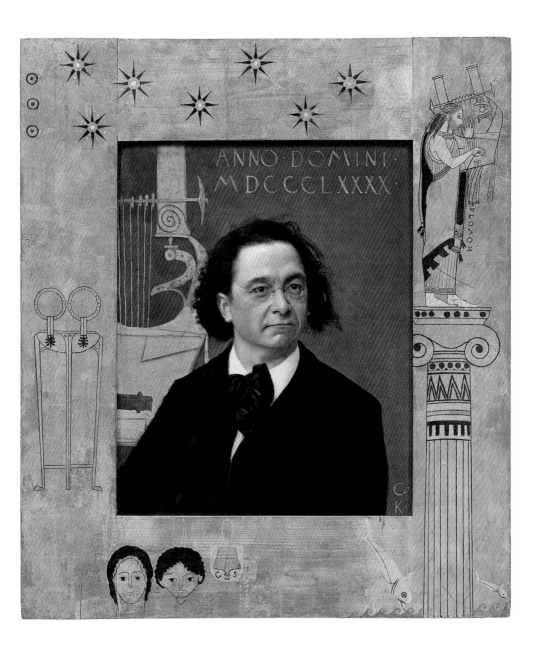

ANNO · DOMINI · MDCCCLXXXX ·

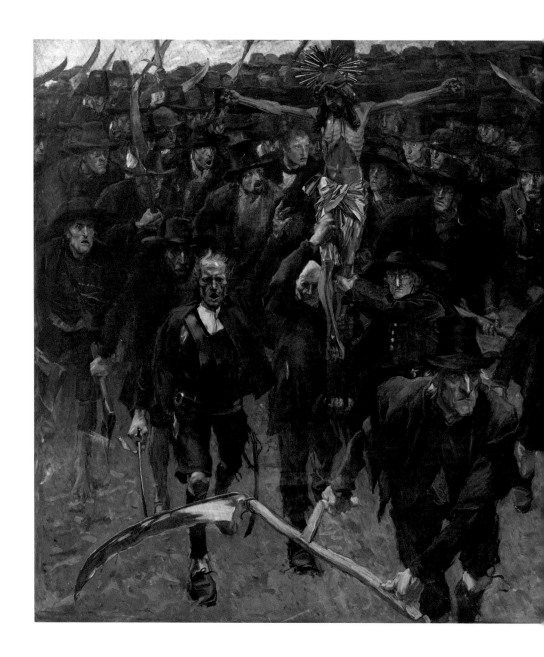

ALBIN EGGER-LIENZ
Stribach in Dölsach near Lienz 1868–1926 Sankt Justina near Bozen
(Bolzano)

The Cross, 1898–1901

Oil on canvas, 310 x 383 cm

Tyrolean State Museums, Department of Modern Art

Inv. no. Gem 1189

WITH WILD, DETERMINED FACES and simple weapons in their hands, but most importantly with a wooden crucifix in their midst, men in Tyrolean costume are attacking the enemy. In a dramatic setting the artist Albin Egger-Lienz from East Tyrol depicts a scene from the Tyrolean rebellion of 1809. The story goes that, in the course of these battles, the Freiburg student Georg Hauger called on a number of Tyrolese farmers who were praying in front of a carved crucifix to join with a small crowd of hunters in the defence of the Lienzer Klause. With a sword in his right hand and his left arm gesturing towards this crucifix, Georg Hauger drives his men on to fight. Right in the foreground is the symbolic figure of a Tyrolean farmer looking like the grim reaper warning of death, who appears to be clearing the way with a scythe that is already stained with blood.

In this early history painting by the artist who just a few years later would develop naturally into an expressionist, Egger-Lienz resolutely heightens the drama of the figurative event. In contrast to the usual history paintings that appear rather more distanced from events, he brings the picture as close as possible to the viewer. The men in the painting, who are intent on battle, are integrated into the field of view in large format and full figure.

Far from producing the usual kind of history painting with a view from the wings, the artist creates an absolutely realistic and direct insight into the Tyrolean Rebellion of 1809 and succeeds in elevating this single scene of the war to a symbolic plane.

EGON SCHIELE
Tulln 1890–1918 Vienna

Correspondence with the Viennese art dealer Guido Arnot, 1914–1918

Postcard: 14.4 x 9.4 cm; letter: 19.2 x 15.2 cm

Tyrolean State Museums, Library at the Ferdinandeum

Inv. no. Autograph Collection

ONE OF THE MOST FASCINATING opportunities for getting closer to other people's personalities is to study their handwriting – the extensive autograph collection of the Library at the Ferdinandeum offers the most diverse possibilities. This applies even more to those personalities who have made a very special effort in connection with the individuality of their handwriting. This undoubtedly applies to Egon Schiele. His use of line, expressive and highly charged, often bordering on the ecstatic, yet very succinct, means that his paintings and graphics remain some of the most exciting works in the history of European art and, together with those of Gustav Klimt, are a popular reflection of the innovative Viennese art scene around 1900.

Schiele was by no means a retiring artist, taking aggressive action in the marketing of his art. For example, very early on he had postcards of his works printed in order to make them popular and unmistakable, such as this one of a drawing of his head in a few brief strokes. The card comes from an envelope containing letters from the artist documenting his intensive correspondence with the Viennese art dealer Guido Arnot. They provide extremely interesting insights into Schiele's intense business relationships and his particular artistic concerns. For example, on a postcard about his next exhibition he asks his gallery owner for his works to be framed with a special rail designed by the famous architect and designer of the Austrian Secession, Josef Hoffmann (1870–1956).

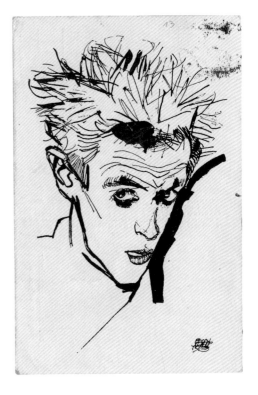

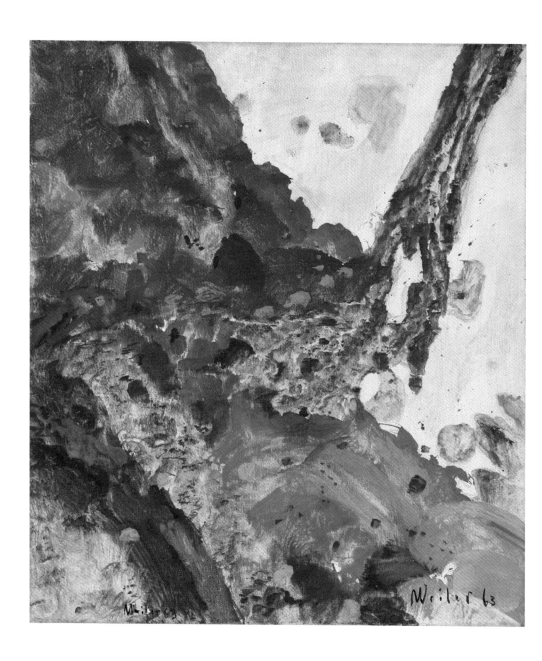

MAX WEILER
Absam 1910–2001 Vienna

Like a Landscape, 1963

Egg tempera on canvas, 80 x 70 cm

Tyrolean State Museums, Department of Modern Art

Inv. no. Gem 2095

THE NAME OF MAX WEILER is especially important in the development of contemporary art in the Tyrol since 1945. He was one of the first artists to abandon the moderate style that followed the expressionist art of, say, Albin Egger-Lienz. His 1948 fresco in the Theresienkirche in the Innsbruck district of Hungerburg caused a scandal. In the years that followed, Max Weiler resolutely turned away from figurative painting and – influenced by the French *art informel* and tachisme – towards abstract art forms. From the early 1950s to the end of his life, his central theme was nature in all the abundance of its form. All the same, his artistic approach to nature was never purely illustrative; for him it was much more about getting into the spirit of a process of creation that is 'like nature'. Weiler gave many of his compositions similar-sounding names.

Particularly in his works in tempera, Weiler created an expansive cosmos with a natural feel that avoids precise assignment to a specific pictorial impression. With the greatest possible artistic sensitivity he set down shapes that constantly switched between microcosm and macrocosm. Fascinated by the fundamental energy of growth processes in nature, he allowed these forms to merge gently into one another. Employing the characteristic effect of tempera paints, which give only partial cover, he succeeded in creating a symbolic image of the permanent natural changes in growth. These forms remind us of rock structures or mosses and lichens as if on cliffs or in forest settings.

Maria Lassnig
Kappel am Krappfeld 1919–2014 Vienna

Self portrait with pig's trotters, 1969
Oil on canvas, 130 x 151 cm
Tyrolean State Museums, Department of Modern Art
Inv no. Gem 3363

WITH HER SENSITIVE yet powerfully concise painting that deals in concentrated form with her own (female) body and its worlds of experience, Maria Lassnig occupies one of the central positions of international painting within contemporary art. In the 1950s and 1960s, her artistic development led her first to an intense confrontation with post-surrealism and *art informel*. The influences of French art and the orientation of Austrian artistic attitudes around the Viennese Galerie nächst St. Stephan are important here. In 1968 she moved to New York for quite a long time. Here she was mainly occupied with tackling the art form of animated film. After returning to Austria in the early 1980s, she developed a type of painting that not only made her own body the key artistic subject but also included it as directly as possible in the painting process as well as in a relationship to the 'product' of the painting that is constantly being varied. In her painting she continually juxtaposes this body with various significant objects and beings, thus also enabling viewers to similarly question their experiences of the world.

In its concise reduction of the composition of the body and the characteristic concentration on unambiguous elements of colour, this painting is one of the artist's early major works showing her particular development towards a form of painting that is extensively related to her own body.

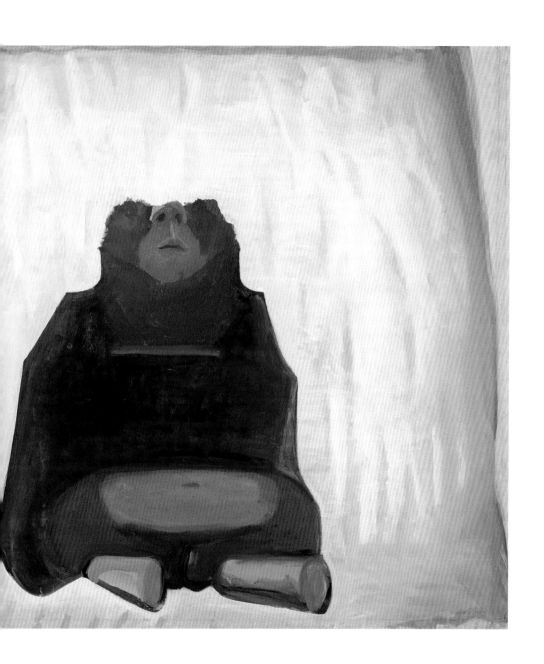

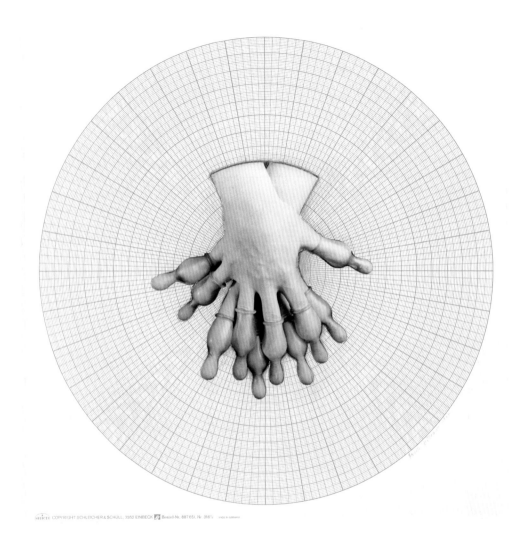

RENATE BERTLMANN
Born 1943, Vienna

Tender Hands (in a circle), 1977

Photo-collage on graph paper, 32.8 x 32.8 cm

Tyrolean State Museums, Department of Prints and Drawings

Inv. no. 20Jh B 437

RENATE BERTLMANN IS AMONG the most significant artists of the feminist avant-garde in Austria. In her diverse artistic work, which includes photography, performances, installations and collage, she concentrates on thematic aspects of eroticism and power, although here she very consciously carves out an alternative female view. She approaches these themes of relationship with great irony, focusing on the theme of touch. She deliberately integrates aspects of popular culture into her compositions, some of it verging on kitsch.

This collage shows a photograph on graph paper, as if the artist were measuring moments of human contact. Babies' dummies are pulled over the fingers of the two approaching hands, preventing direct contact between them. Erotic associations and the role model of the woman as mother determine the message contained in the artwork. The artist was devoting particular attention to the theme of tenderness at the time this work was being created.

Although it has been shown a number of times in exhibitions, the work of this feminist artist only became known to a wider public in 2019, when she was the first female artist to have a solo show in the Austrian Pavilion at the Venice Biennale.

A Million Alpine Butterflies and Moths

Drawer from the lepidoptera collection with specimens of the willowherb hawkmoth, undated

Dry preparations, 51 x 42 cm

Tyrolean State Museums, Department of Natural History

Inv. no. Lepidoptera case LEP 124 088 00

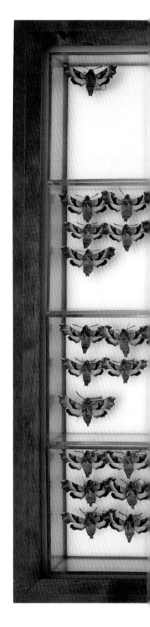

THIS EXHIBIT OF WILLOWHERB hawkmoths offers a glimpse into the extensive collection of butterflies and moths of the Tyrolean State Museums. Contained in some 12,000 drawers is one of the internationally most important scientific documentations of the diversity of lepidoptera. In particular, the presence of these insects in the Alpine region is widely represented. This collection of over a million specimens has particular significance because several hundred of them are irreplaceable holotypes that give their name to a species. In the international scientific world, known (and newly discovered) species are described in accordance with these insects.

Such a diversity of documentation is essential in order to be able to run scientifically based biodiversity research. Only in this way can the changes in our environment due to the extinction of species, or their rediscovery, be recognised. Important questions concerning the protection of nature and the environment are based on this research. These collections are of course also documented in the light of the most recent genetic investigation methods and there are currently approximately 30,000 examples of genetic fingerprints available.

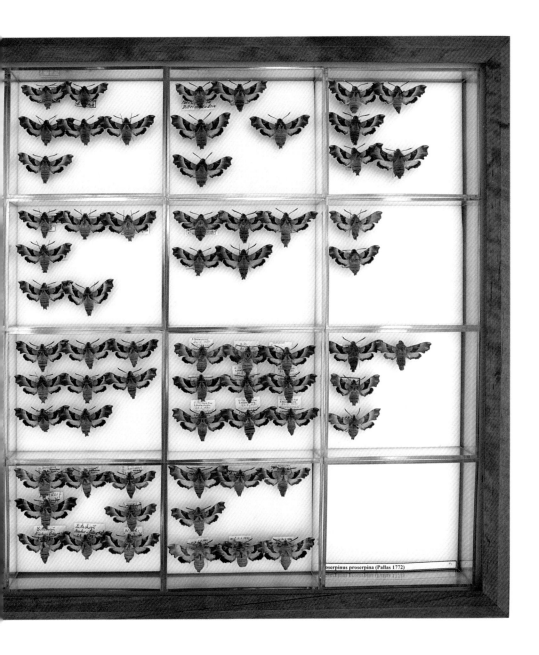

roserpinus proserpina (Pallas 1772)

ACKNOWLEDGEMENTS

The author would like to thank the staff of the Tyrolean State Museums, particularly Karl Berger, Ralf Bormann, Franz Gratl, Peter Huemer, Sonja Ortner, Peter Scholz, Roland Sila, Wolfgang Sölder, Claudia Sporer-Heis and Florian Waldvogel, for their help with the texts and images. He is especially grateful to Astrid Flögel for coordinating the project as well as copy-editing and proofreading the texts.

Texts © Tyrolean State Museums and Peter Assmann
Images © Tyrolean State Museums, except for the top two pictures on p. 5: © Alexander Haiden; third picture down on p. 5: © Wolfgang Lackner; bottom picture on p. 5: © Mario Webhofer/W9 Studios. For reproduced works by Renate Bertlmann © Bildrecht, Vienna 2021; Maria Lassnig © Maria Lassnig Stiftung/Bildrecht, Vienna 2021; Max Weiler © Robert Najar.

Project coordinators: Astrid Flögel (Tyrolean State Museums) and Laura Fox (Scala Arts & Heritage Publishers Ltd)
Editor: Ingrid Price Gschlössl in association with First Edition Translations Ltd
Design: Linda Lundin, Park Studio
Translator: Rae Walter in association with First Edition Translations Ltd
Printed and bound in Turkey

First published in 2021 by
Scala Arts & Heritage Publishers Ltd
Registered address:
27 Old Gloucester Street
London WC1N 3AX, UK
www.scalapublishers.com

In association with
Tiroler Landesmuseen-
Betriebsgesellschaft m.b.H.
Museumstraße 15
6020 Innsbruck
Austria
www.tiroler-landesmuseen.at

This edition © Scala Arts & Heritage Publishers Ltd, 2021

ISBN: 978-1-78551-366-4
10 9 8 7 6 5 4 3 2 1

FRONT COVER:
JACQUES DE GHEYN II
OR DIRCK DE VRIES
(ATTRIBUTED)
Portrait of a Draughtsman, c.1600
(see pp. 34–5)

FRONT INSIDE COVER:
Exterior view of the Ferdinandeum
© Wolfgang Lackner

FRONTISPIECE:
ROSALBA CARRIERA
Portrait of a Lady, c.1730
(see pp. 50–1)

BACK COVER:
Towel-holder (Vanitas), Second half of seventeeth century
(see pp. 46–7)

BACK INSIDE COVER:
Mag. Dr. Peter Assmann, Director of the Tyrolean State Museums
© Wolfgang Lackner